DINOSAUR
Follow-the-Dots
Coloring Book

Patricia J. Wynne

DOVER PUBLICATIONS, INC.
Mineola, New York

Bibliographical Note

Dinosaur Follow-the-Dots Coloring Book is a new work,
first published by Dover Publications, Inc., in 1994.

International Standard Book Number

ISBN-13: 978-0-486-27991-6
ISBN-10: 0-486-27991-X

Manufactured in the United States by Courier Corporation
27991X13
www.doverpublications.com

Publisher's Note

This is a picture book full of dinosaurs eating, fighting, swimming and flying. But the pictures aren't finished yet! You have to fill in the rest of their bodies by connecting the dots in each picture and coloring them in. To connect the dots just take a pen or pencil (or whatever you prefer) and draw a line from dot 1 to dot 2, from dot 2 to dot 3, and so on, until the whole dinosaur appears. Then color it in however you like. Each puzzle comes with a question or a clue about the dinosaur on that page. You might even be able to guess the dinosaur before completing the puzzle! In the very back of the book, there is a key with the answers to each puzzle, along with a pronunciation guide. It will also tell you what the name of each dinosaur really means. For example, did you know that the word "dinosaur" means "terrible lizard?" And every dinosaur's name has its own special meaning. Some of these giant lizards will be familiar to you; some will be very strange. They are all waiting for you to bring them colorfully to life. When you're done, you'll have your own very special dinosaur book. Enjoy!

DINOSAUR
Follow-the-Dots
Coloring Book

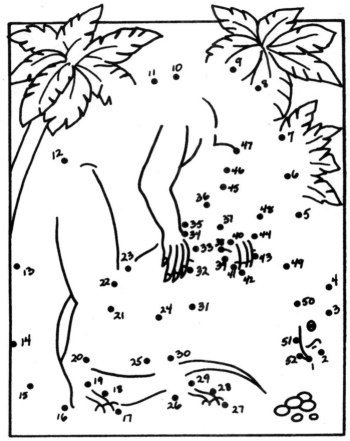

This large dinosaur from Africa swallowed rocks to
help him digest his food.

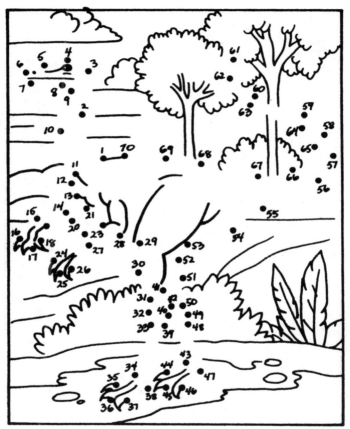

It looked like an ostrich, it ran like an ostrich, but was it really an ostrich?

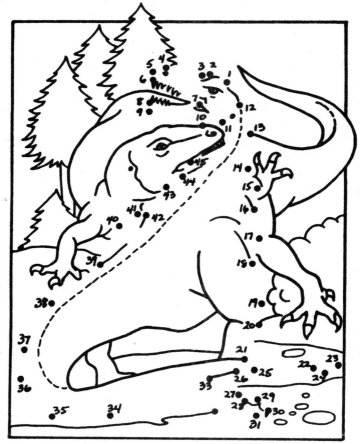

Who is fighting so fiercely with this Allosaurus?

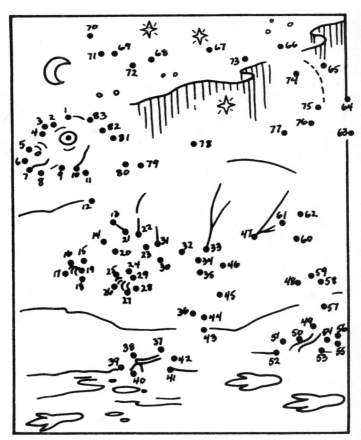

This tiny dinosaur lived near the South Pole.

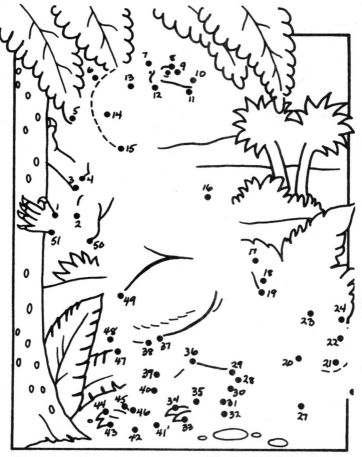

This awesome creature was one of the biggest dinosaurs of the Triassic.

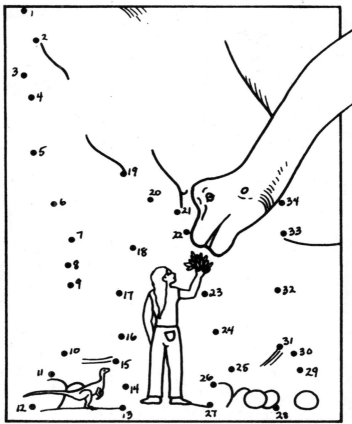

In this picture you can see one of the smallest dino-
saurs and some huge dinosaur's eggs. If you could
stand near a dinosaur do you think you'd be as tall as
its knee?

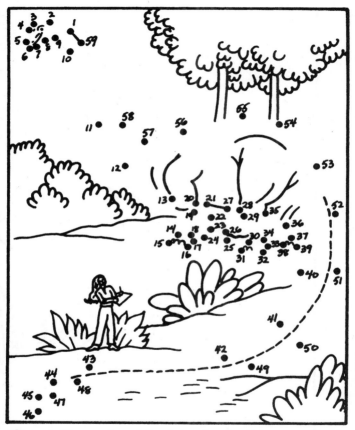

If seventeen paleontologists stood on one another's heads, they would be as tall as this dinosaur.

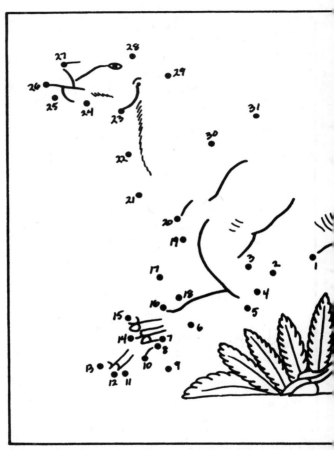

This famous dinosaur, which lived in Europe, was on

the first to be discovered.

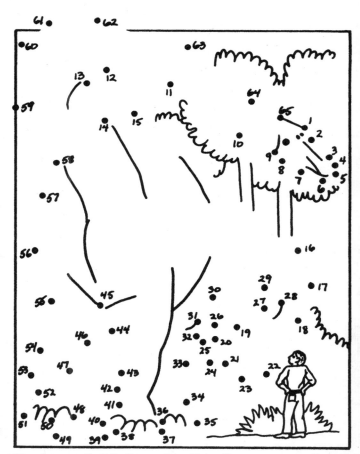

Ten bones that belonged to this dinosaur were found.
They were so big, he was named "Earthshaker."

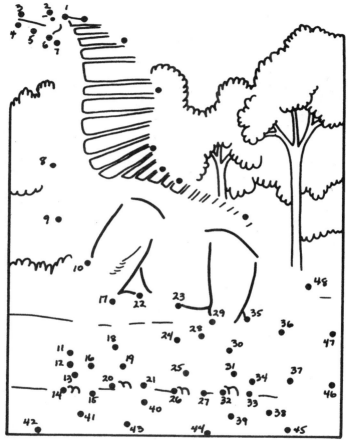

This strange dinosaur was found in Argentina. He was thirty feet long!

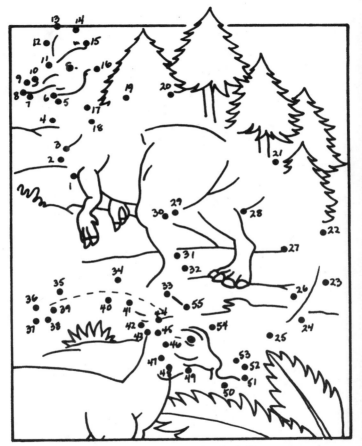

These handsome dinosaurs had different crests on their heads.

12

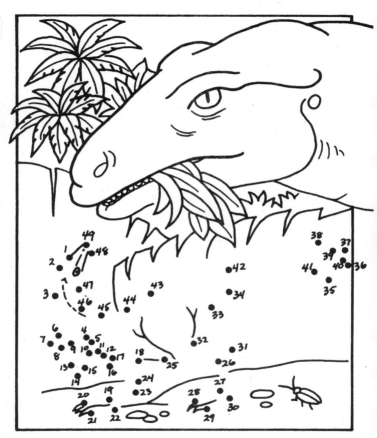

Plateosaurus, who lived during the Triassic, meets one of the tiniest dinosaurs.

One of the things paleontologists hunt for is hidden in this picture.

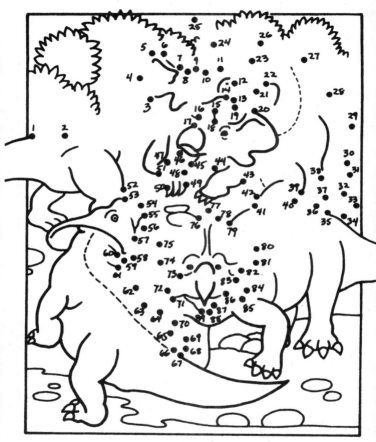

How many Protoceratopses are in this group?

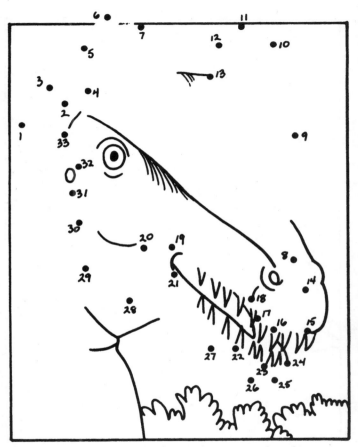

This dinosaur had two big crests on its head.

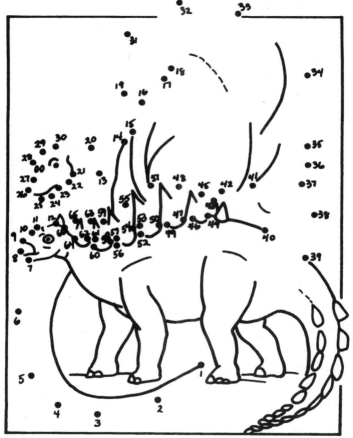

One of these strange dinosaurs came from England, and the other from India. Do you want to know their names?

17

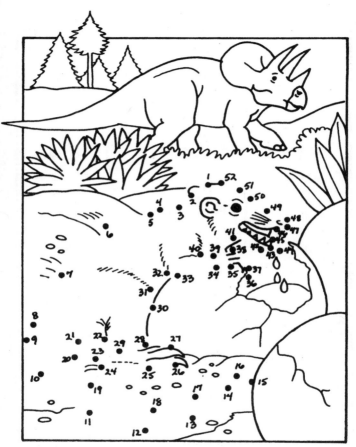

Someone is stealing eggs from the dinosaur's nest.
Who might that be?

18

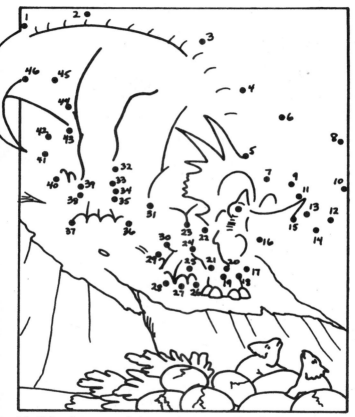

Mother dinosaur brings dinner to her babies. Do you know her name?

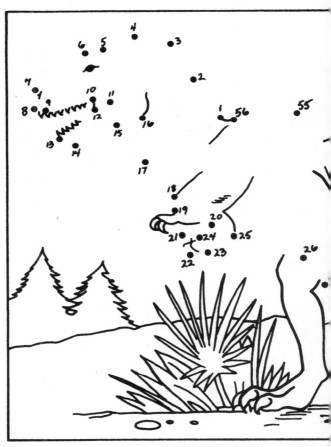

This is the greatest and most famous of them all!

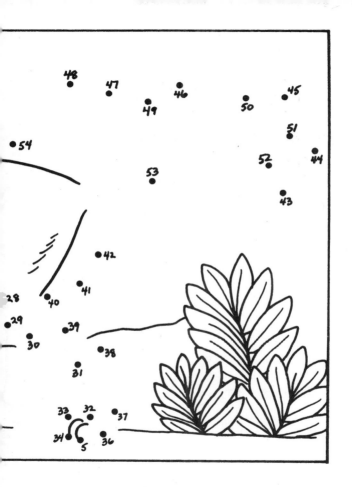

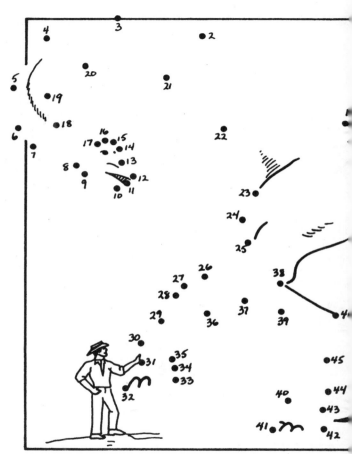

This group of dinosaurs was really big and heavy.

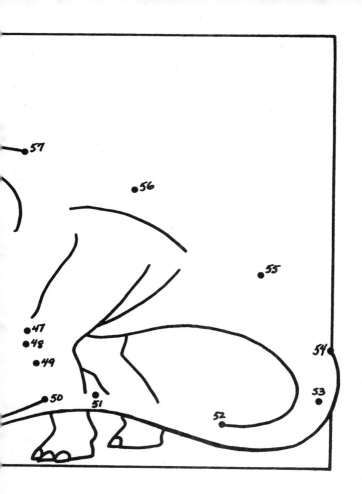

57

56

55

47

48

49

54

53

50

51

52

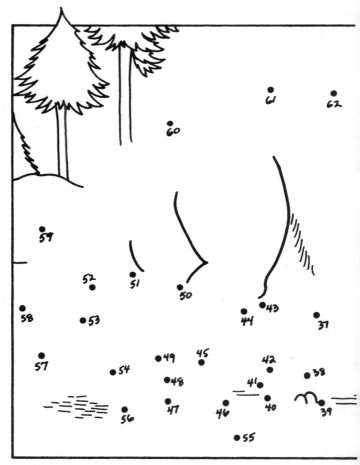

You will find three horns on this dinosaur, and this is

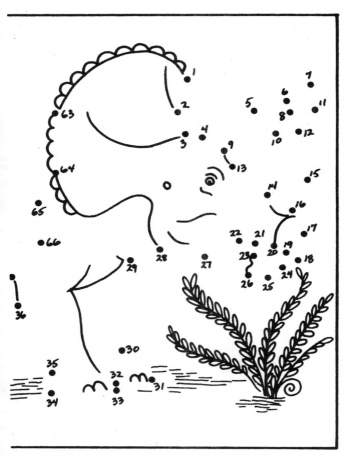

why it was given its name.

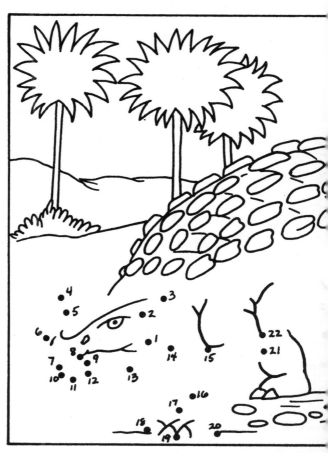

Tyrannosaurus Rex didn't always win!

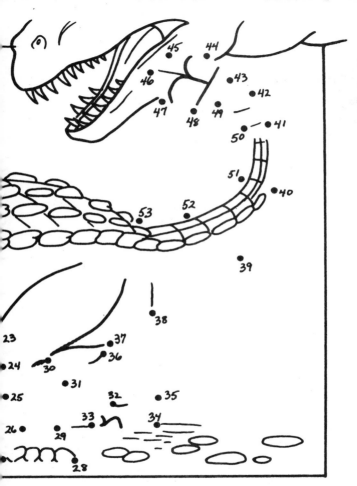

Who is fighting him here?

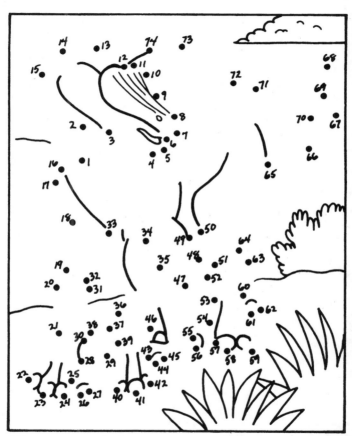

This is one of the many dinosaurs that lived in Australia.

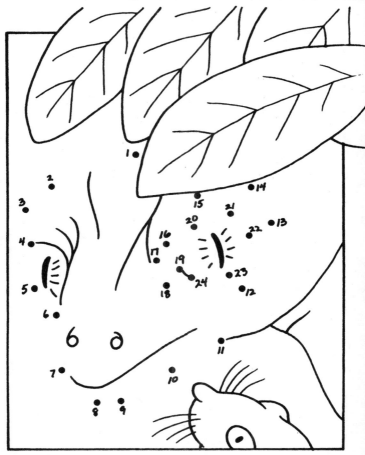

One part of this tiny dinosaur was very big.

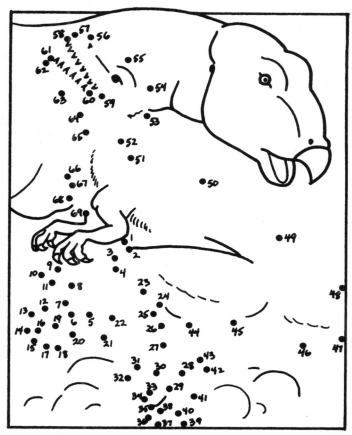

Deinonychus is attacking someone with its very big claws.

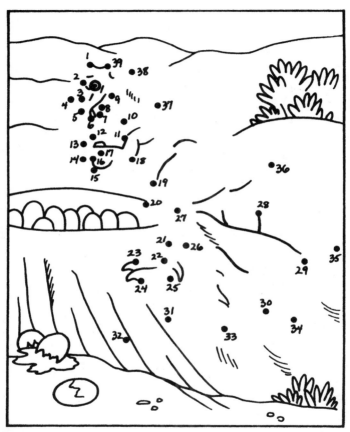

There's a sneaky thief near the eggs of the Hadrosaur!

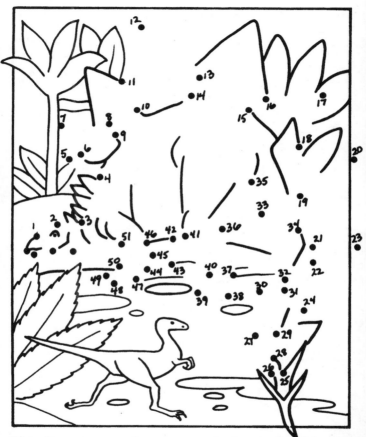

This dinosaur wore heavy armor, but never fought with anyone!

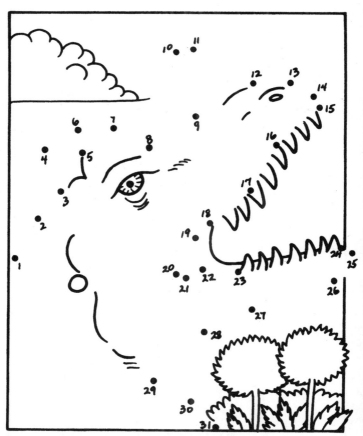

You may think you know this dinosaur, but there's a big surprise!

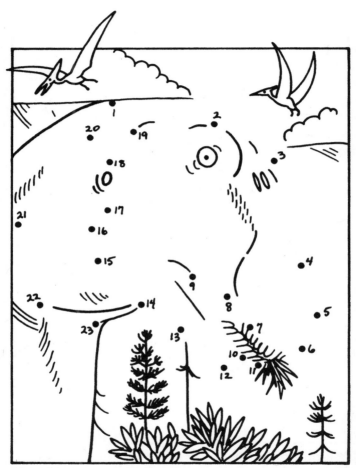

This dinosaur was taller than trees.

34

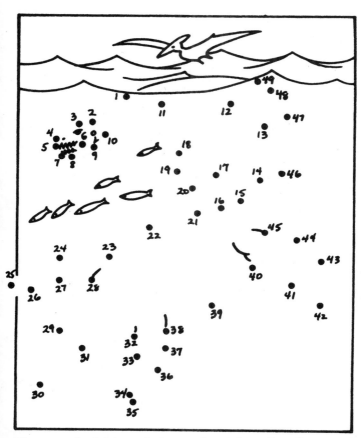

This may look like a dinosaur, but it's really a fierce sea creature.

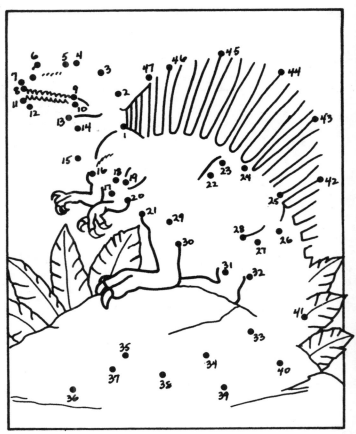

This is not a swordfish! It really is a dinosaur. Do you know its name?

36

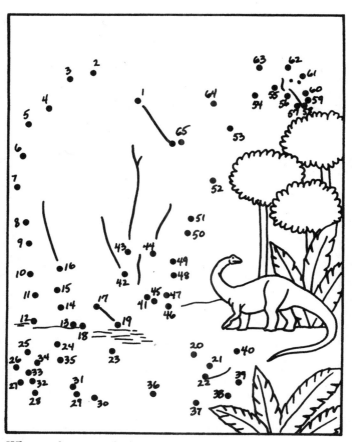

What is looming behind the baby Apatosaurus?

37

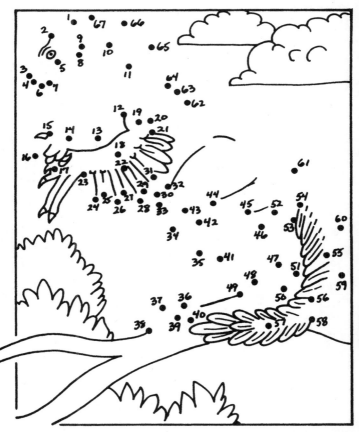

Some dinosaurs may have looked like birds. Do you think they had feathers?

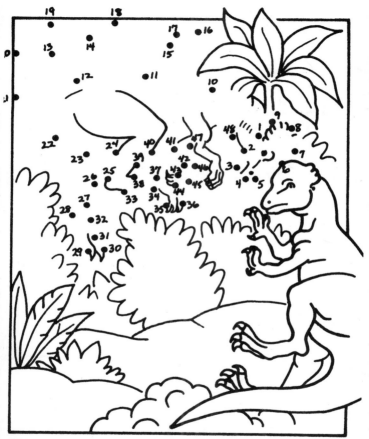

These dinosaurs fight by banging their very hard heads together.

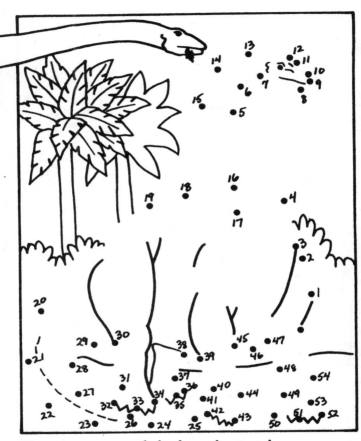

These two sauropods had very long necks.

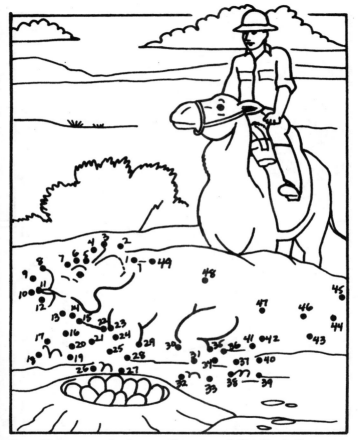

Roy Chapman Andrews discovered the first dinosaur eggs in the Gobi desert. Do you know who they belonged to?

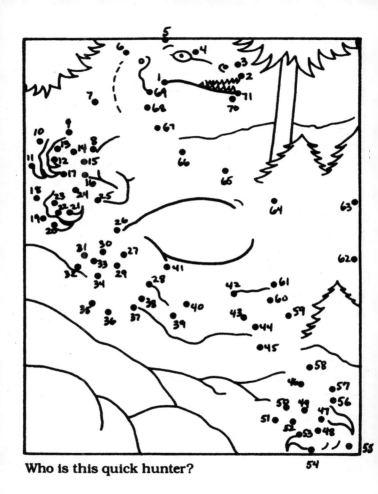

Who is this quick hunter?

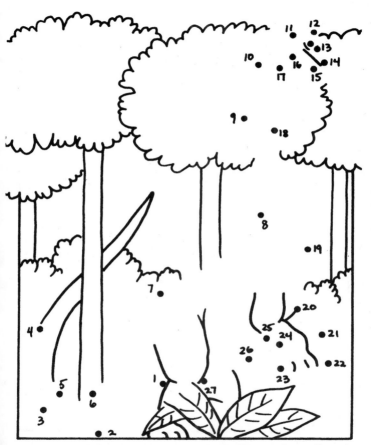

Who is the very large animal lurking in the tall cone trees?

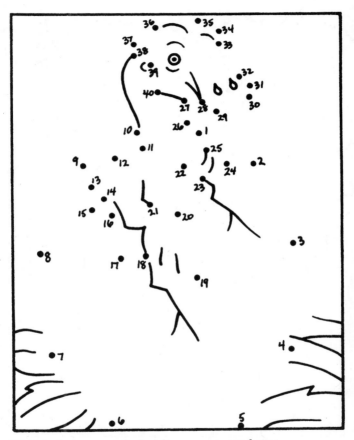

This is how some baby dinosaurs are born.

44

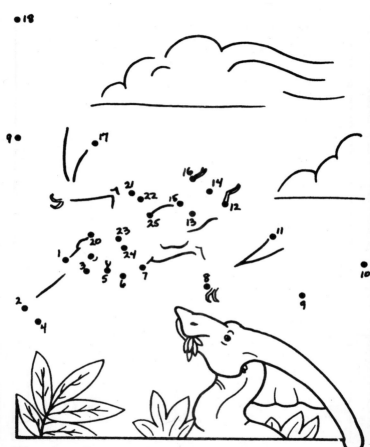

What does Parasaurolophus see in the sky?

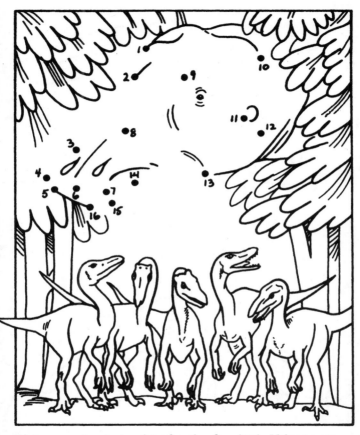

This surprise is too big for the five little Velociraptors to eat!

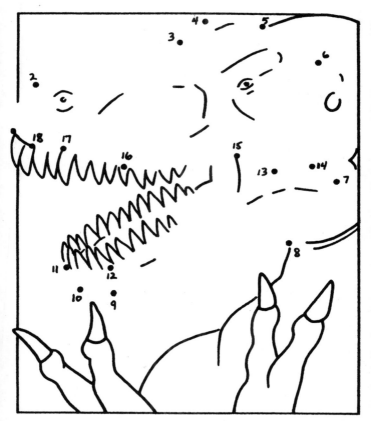

Look at these vicious claws. Can you guess who is their owner?

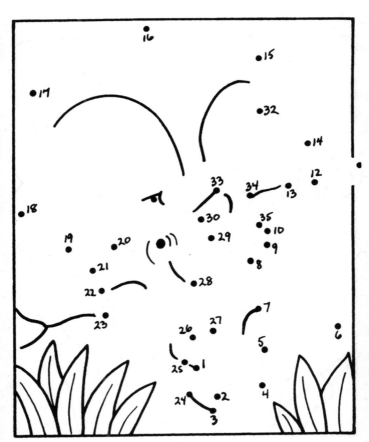

This dinosaur is named for his horns.

48

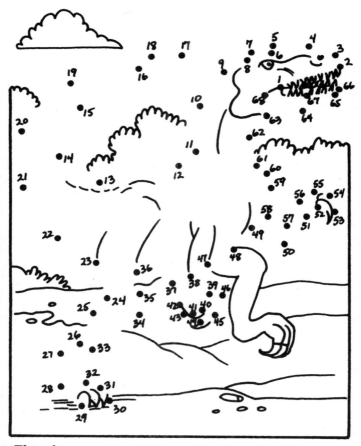

This dinosaur is a little smaller than the Allosaurus, and was found in China.

49

Solutions

1. Massospondylus (MASS-oh-SPAWN-dill-us), meaning "greater vertebra"

2. No, it's a Struthiomimus (STROO-theo-MY-mus), meaning "ostrich mimic"

3. Another Allosaurus (AL-oh-SAW-rus), meaning "leaping lizard"

4. Leaellynasaura (lee-EL-in-ah-SAW-rah), meaning "Leaellyn's lizard"

5. Plateosaurus (PLAY-teo-SAW-rus), meaning "flat lizard"

6. Follow the dots and see!

7. Diplodocus (dip-LAHD-oc-us), meaning "double beam"

8. Iguanodon (ig-WAHN-oh-don), meaning "iguana tooth"

10. Seismosaurus (SIZE-mo-SAW-rus), meaning "earthshaker lizard"

11. Amargasaurus (ah-MAR-ga-SAW-rus), meaning "lizard of Amargosa"

12. Hadrosaurus (HAD-roh-SAW-rus), meaning "large lizard"

13. Saltopus (sal-TOE-pus), meaning "leaping foot"

14. Bone fossil

15. Four

16. Dilophosaurus (DILL-oh-fo-SAW-rus), meaning "double-crested lizard"

17. TOP: Barapasaurus (BAR-a-pa-SAW-rus), meaning "big-legged lizard"; BOTTOM: Polacanthus (POLE-a-CAN-thus), meaning "many-thorned spine"

18. Early mammal

19. Styracosaurus (sty-RACK-oh-SAW-rus), meaning "spiked lizard"

20. Tyrannosaurus Rex (ty-RAN-oh-SAW-rus REKS), meaning "tyrant-lizard king"

22. Brachiosaurs (BREAK-ee-oh-SAWRS), meaning "arm lizard"; examples of Brachiosaurs are: Supersaurus, meaning "super lizard" and Ultrasaurus, meaning "ultimate lizard"

24. Triceratops (try-SAIR-a-tops), meaning "three-horned face"

26. Euoplocephalus (YOU-oh-ploh-SEF-a-lus), meaning "well-plated head"

28. Muttaburra Iguanodon (MUH-ta-BUH-ra ~), the Iguanodon of Muttaburra (Australia)

29. Stenonychosaurus (STEN-oh-NY-ko-SAW-rus), meaning "narrow claw"

30. Tenontosaurus (ten-ON-toh-SAW-rus), meaning "tendoned lizard"; attacking Tenontosaurus is Deinonychus (DAY-noh-NY-kus), whose name means "terrible claw"

31. Oviraptor (O-vi-RAP-ter), meaning "egg-stealer"

32. Stegosaurus (STEG-oh-SAW-rus), meaning "plate lizard"

33. Ceratosaurus (se-RAT-oh-SAW-rus), meaning "horned lizard"

34. Supersaurus (see number 21)

35. Elasmosaurus (ee-LAZ-moh-SAW-rus), meaning "ribbon lizard"

36. Spinosaurus (SPY-noh-SAW-rus), meaning "spiny lizard"

37. Don't worry—it's mother Apatosaurus (a-PAT-oh-SAW-rus), meaning "deceptive lizard"

38. Avimimus (A-vi-MY-mus), meaning "bird mimic" (no feathers)

39. Pachycephalosaurus (PACK-ee-SEF-a-lo-SAW-rus), meaning "thick-headed lizard"

40. Sauropod (SAW-roh-POD) means "lizard-footed"; pictured here are Diplodocus and Apatosaurus

41. Protoceratops (PRO-toe-SAIR-a-tops), meaning "first horned-face"

42. Velociraptor (vel-OSS-i-RAP-ter), meaning "swift robber"

43. Looks like another Apatosaurus!

44. Hatched from eggs, not unlike baby chicks

45. Pteranodon (tear-ON-a-DON), meaning "winged and toothless"; Pteranodon is pictured with Parasaurolophus (PEAR-ah-saw-RAWL-oh-fuss), whose name means "like the Saurolophus" or "like the ridged lizard"

46. A full-grown Hadrosaurus!

47. Tyrannosaurus Rex

48. Another Triceratops

49. Yangchuanosaurus (YANG-chew-ON-oh-SAW-rus), meaning "lizard of Yang Chuan"